ST ANDREWS

HISTORY TOUR

First published 2017

Amberley Publishing
The Hill, Stroud,
Gloucestershire, GL5 4EP
www.amberley-books.com

Copyright © Helen Cook, 2017
Map contains Ordnance Survey data
© Crown copyright and database right
[2017]

The right of Helen Cook to be
identified as the Author of this work
has been asserted in accordance with
the Copyrights, Designs and Patents
Act 1988.

British Library Cataloguing in
Publication Data.
A catalogue record for this book is
available from the British Library.

ISBN 978 1 4456 5767 7 (print)
ISBN 978 1 4456 5768 4 (ebook)

Origination by Amberley Publishing.
Printed in Great Britain.

INTRODUCTION

St Andrews, 'the burgh of St Andrew', a historic European city, was founded sometime between 1144 and 1153 by Bishop Robert with royal permission, and the setting of the new burgh was a beautiful one. It overlooked St Andrews Bay with the Angus hills to the north, and the Grampians in the far distance. The bishop's burgh absorbed the much older Celtic religious settlement of Kinrimund/Kilrymont (one of the oldest in Scotland) centred on the high ground at the Kirkhill above the harbour, which in time became one of the country's earliest and most prosperous burghs.

Saints, hermits and 'three virgin saints', it is said, brought the relics of the 'blessed Andrew' to where his city would be established. Those saintly relics ensured that St Andrews became one of the most important pilgrim cities in medieval Europe, the seat of Scotland's most important bishopric and the site of the country's largest cathedral, the now ruined great cathedral church of St Andrew, the focal point of medieval St Andrews.

Founded in 1160, it was consecrated in July 1318 in the presence of King Robert the Bruce, when thanks were also given for victory over the English at Bannockburn in June 1314. The shrine of St Andrew was at the eastern end of the cathedral, where its building had begun.

The year 1472 saw the Bishop of St Andrews become Archbishop and Primate of Scotland. Until the Reformation (1559), St Andrews, with its Augustinian priory, episcopal palace, St Andrews Castle and its university founded in 1410–14, became the ecclesiastical capital of Scotland – an important, influential, cosmopolitan town with Scottish royal and European connections.

In the troubled times after the Reformation, St Andrews gradually lost its importance. The town remained in recession until the Victorian period saw its regeneration, expansion and promotion as a desirable residential town with elegant new houses and streets, a seaside resort and golfing town.

In the early twentieth century St Andrews was a quiet but growing residential, university and golfing town with a summer season. In 1914 its population was 7,000. The population had increased to 9,987 by the 1930s, and by 1948–51 the university had more than 2,000 students. Those years were marked by the First World War and the Second World War.

Before the First World War many of the town's larger houses had resident domestic staff, and both coalmen making deliveries and message boys were a common sight. The Second World War saw some hotels and a number of large houses occupied by the military, while West Sands was fortified against invasion with barbed wire and anti-tank blocks. Shops were concentrated in Market Street, South Street, Church Street (boasting a tinsmith) and Bell Street, and by the end of the 1940s numbered around 226, which provided a variety of goods and services.

In the world of golf, St Andreans, as golf professionals, greenkeepers, golf course designers and teachers, promoted golf at home and abroad, while St Andrews-crafted golf clubs were in demand. The year 1921 saw St Andrews-born American Jock Hutchinson win the British Open Championship at St Andrews. Women's golf continued to grow in importance, and crowds of spectators watched Miss Grant-Suttie win the Ladies' Scottish Championship of 1911 at St Andrews. The first motorcycle races were held on the West Sands in 1909.

St Andrews Town Council began to build council houses for rent in the 1920s on 'greenfield' sites beyond the Kinness Burn – building began with Sloan Street (1922) and Lamond Drive (1925). The year 1934 saw 498 houses built, known as 'the new houses'.

Spring 1926 saw the revival, with the university's approval, of the student Kate Kennedy procession as an historical pageant of St Andrews and Scotland. The procession had been banned in 1881 as it was deemed too rowdy.

St Andrews Preservation Trust was formed in 1937 'to preserve for the benefit of the public, the amenities and historic character of the City and Royal Burgh of St Andrews'. Support was promised by the National Trust for Scotland. The same year, in May, the first public performance took place in the first tiny Byre Theatre in Abbey Street.

No new local-authority primary or secondary schools built were beyond the Kinness Burn until Langlands Primary of 1954. The 1940s saw

the town's first public library opening – in a converted shop in Church Square. It was a Fife County Branch Library (with children's books) and later relocated to Queen's Gardens.

St Andrews had a railway from 1852–1969. Its station is now part of the Petheram Bridge car park. Until the outbreak of war in 1939, the horse-drawn hansom cabs, owned by William Johnston, No. 117 Market Street and Nos 104–108 North Street, met trains on their arrival and departure at St Andrews station. The cabs added an unusual period touch to the St Andrews streets, and were popular for university balls and dances.

In contrast, the first St Andrew Civil Air Display took place at the West Sands in 1919, when passenger flights were available. The planes that took part were from Leuchars airbase.

The economy of modern St Andrews, with a population of around 17,000, is still based on its university (which has around 7,775 students), the tourist and conference industry, and as the 'Home of Golf'. All seven golf courses at St Andrews Links can be played by anyone.

Since the 1960s the town has grown significantly in size and seen many changes. As a result of the Local Government (Scotland) Act, St Andrews lost its town council in 1975, and the North-East Fife District Council was set up. 'Greenfield' sites have been developed for private housing, primary schools have been built and shopping is no longer confined to the town centre, while 2009 saw the new NHS St Andrews Community Hospital opened in Largo Road.

Today St Andrews is a cosmopolitan town enriched with worldwide contacts through its golf, university, tourists and those who come from other continents to settle in the town. Perhaps the most famous are the Duke and Duchess of Cambridge, Prince William and his wife Katherine, who are both alumni of St Andrews University – the third oldest university in the United Kingdom.

The royal burgh of St Andrews is a fascinating tapestry of the old and the new. Perhaps the images and text in *St Andrews History Tour* will recall memories for St Andreans, and former St Andreans, and provide information about and perspective on the town for those who are new to it.

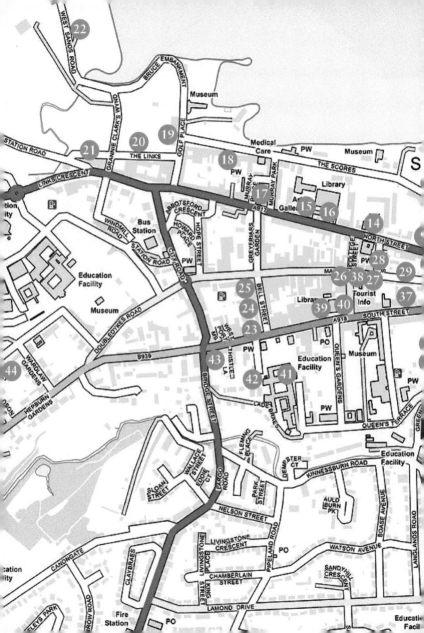

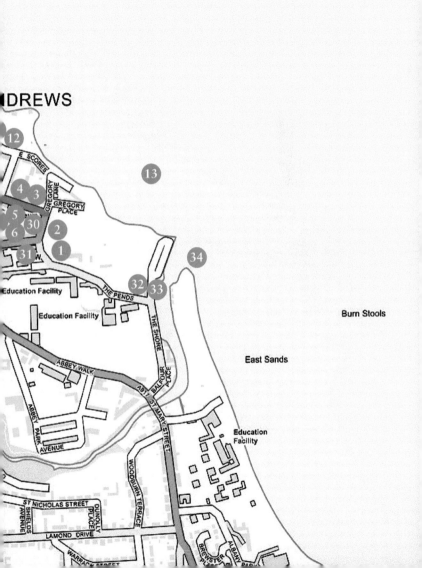

DREWS

Burn Stools

East Sands

Education Facility

Education Facility

Education Facility

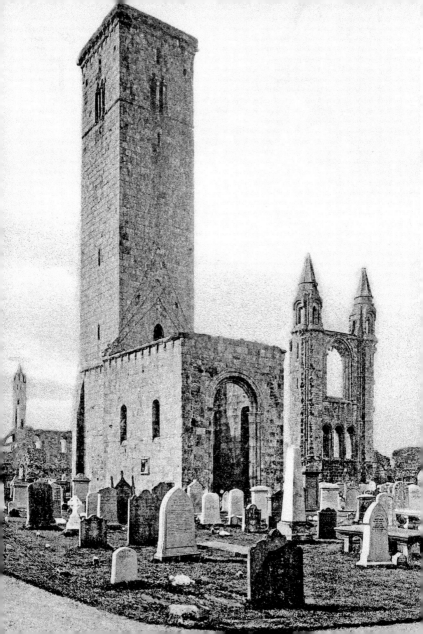

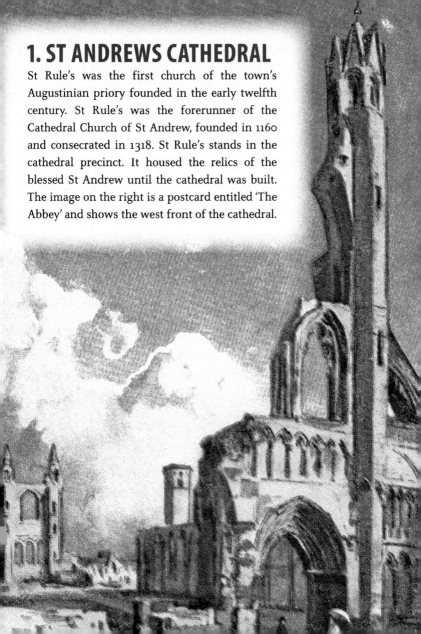

1. ST ANDREWS CATHEDRAL

St Rule's was the first church of the town's Augustinian priory founded in the early twelfth century. St Rule's was the forerunner of the Cathedral Church of St Andrew, founded in 1160 and consecrated in 1318. St Rule's stands in the cathedral precinct. It housed the relics of the blessed St Andrew until the cathedral was built. The image on the right is a postcard entitled 'The Abbey' and shows the west front of the cathedral.

2. ST ANDREWS WAR MEMORIAL

On 23 September 1922 the St Andrews War Memorial was unveiled by Earl Haig. Set into the wall of the cathedral's burial ground, the memorial looks west along North Street and commemorated the 185 men of St Andrews who lost their lives in the First World War. The memorial was designed by Sir Robert Lorimer, architect of the Thistle Chapel, St Giles' Cathedral, Edinburgh, and the Scottish National War Memorial, Edinburgh Castle. The Lorimer family had a close connection with Kellie Castle near Pittenweem.

Part of the west front of the cathedral can be seen in the background (right). Note: in 1914 the population of St Andrews was only 7,000. (Nor S. 362.2, Unveiling of War Memorial 23 September 1922. Reproduced courtesy of The St Andrews Preservation Trust)

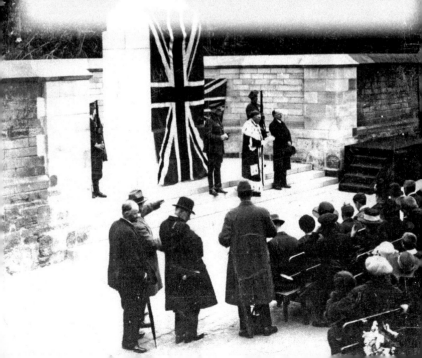

3. NOS 19–23 NORTH STREET

This is Nos 19–23 North Street in around 2009 with its pillared forestair, the only one left in St Andrews. In certain lights the grey sandstone of St Andrews has golden honey-coloured tints.

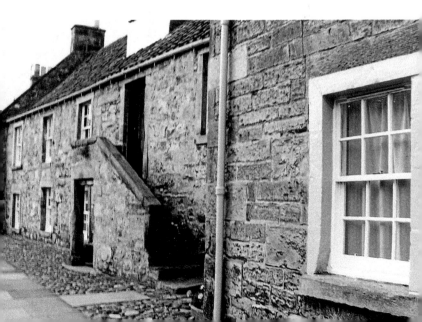

4. THE LADYHEAD FISHER HOMES

Nos 19–23 North Street in the Ladyhead, the town's old fishing quarter, at the east end of North Street. Here lines are being baited with mussels from the River Eden. Nos 19–23 escaped demolition and were renovated in 1949 as one house. Its forestair is the only pillared one left in St Andrews. Ladyhead fisher homes were demolished in March 1937 to provide a site for the rectory of All Saints Church. Once home to around 200 fisher families, the Ladyhead featured in some of the earliest St Andrews photographs (calotypes) when St Andrews was a centre for experimental photography in the 1840s.

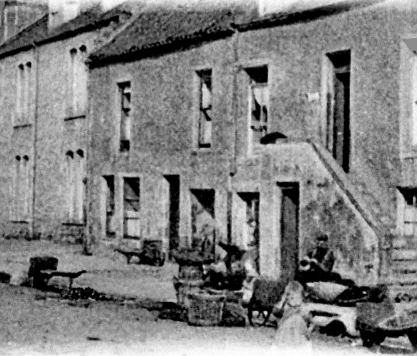

North Street, St. Andrews

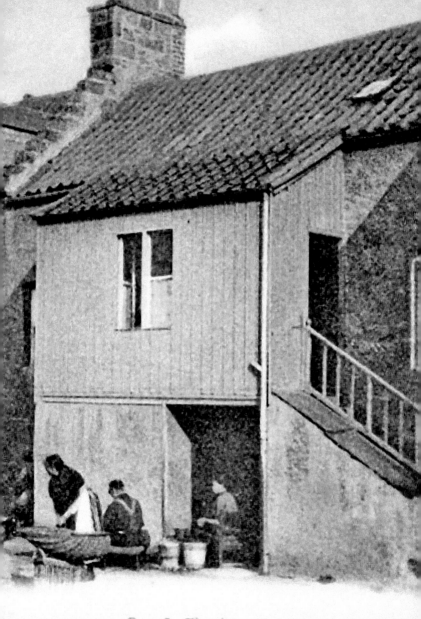

5. NORTH STREET

In 1922 former fisherman David Brown took over the grocery from James Robb. David Brown and his daughter Lettie around 1930 in front of the shop. The shop was open seven days a week, and it is now the Northpoint Café.

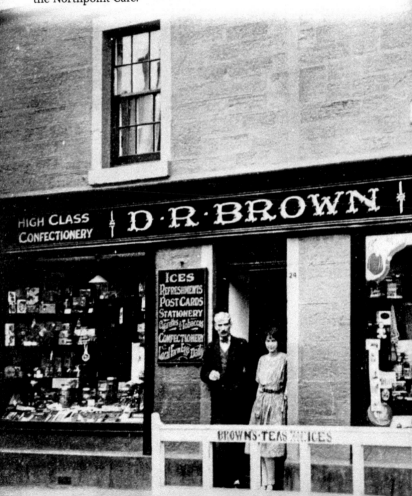

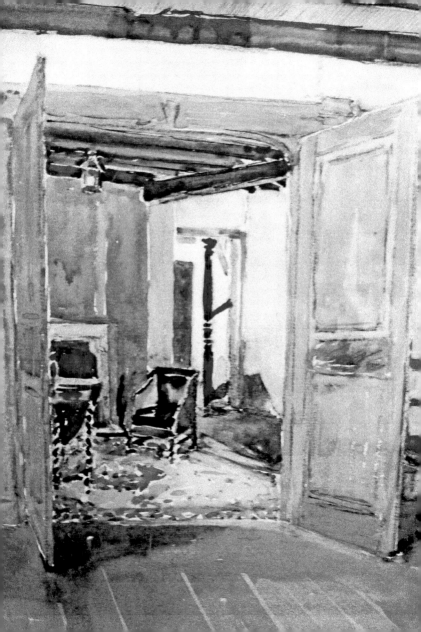

6. NOS 12–20 NORTH STREET

Nos 12–20 North Street in the Ladyhead in the 1930s, before its tenants were rehoused in modern council houses beyond the Kinness Burn. In 1851 No. 12 had four rooms, each room housing a family of eight or nine. In 1937 the St Andrews architect James H. Scott bought Nos 12–20 North Street and restored this old fisher property as his home, saving it from demolition. The property was acquired by St Andrews Preservation Trust in 1962, who kept No. 12 for their own use. No. 12 North Street today houses their museum. The rest of the property was sold as a private house. The two-seater privy (sited in No. 12's garden), which once served all the families in Nos 12–20, has been recently restored by the trust. The painting by Ada Walker is of the interior of Nos 12–20 North Street when it was the home of James H. Scott. (SAAPT 2002 31, Interior, 12 North Street by Ada Walker. Reproduced courtesy of the St Andrews Preservation Trust)

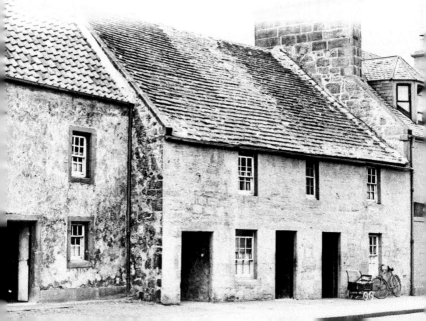

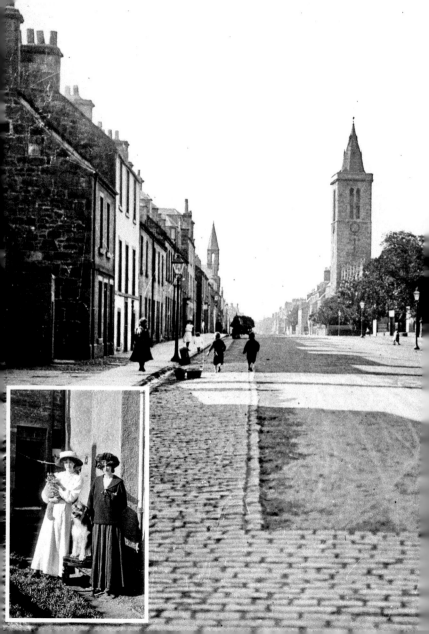

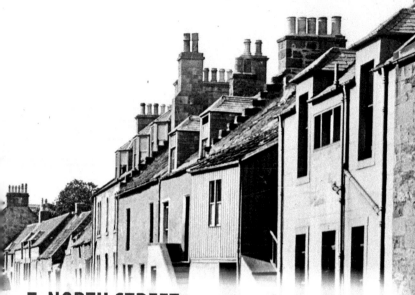

7. NORTH STREET

Looking west along North Street in the 1890s to the tower of St Salvator's College, founded in 1450. The tower's spire dates from the mid-sixteenth century. The distant small fisher houses on the right were demolished to make way for the university's Younger Graduation Hall of 1929. To make way for the rectory of All Saints Church, the crow-stepped, gabled fisher houses on the immediate right, which were of considerable age, were demolished in March 1937. The inset shows the same part of North Street today but looking east. The red-roofed rectory can be glimpsed on the far right beside the university's Gannochy Hall, with the Younger Graduation Hall in the centre. The white building, No. 35 North Street (now the property of St Andrews University), was once known as 'Beethoven House'. It can be seen (on the right) beside the lamp post and trees.

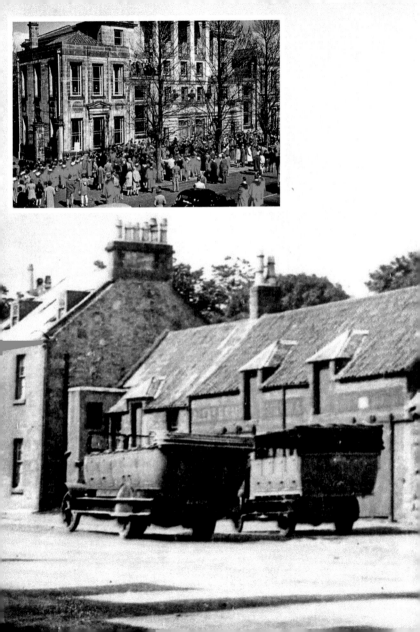

8. NORTH STREET – THE LADYHEAD

The site of the Younger Graduation Hall, photographed by Thomas Howie in 1922, before the former small fisher houses were demolished. 'Beethoven House' is on the far left. On the right is part of the steading of one of the former St Andrews burgh farms, an estimated twenty in number; they had steadings, dairys, and byres, within the town, but by 1952 none existed. Their tenants grazed cows, and practised a form of medieval strip farming on the town's perimeter.

The inset shows students in April 1962 waiting outside the Younger Graduation Hall to attend the installation of Sir Charles Snow, CBE (1905–80), scientist, civil servant, man of letters, and novelist, as rector of St Andrews University. Scarlet undergraduate gowns are much in evidence, gowns that since 1838 have been full length of red frieze with collar and yoke of velvet. Elizabeth, Duchess of York (the late Queen Mother), opened the Younger Hall on 28 June 1929. The funds for its building were provided by Dr James and Mrs Annie Younger of Mount Melville House, St Andrews.

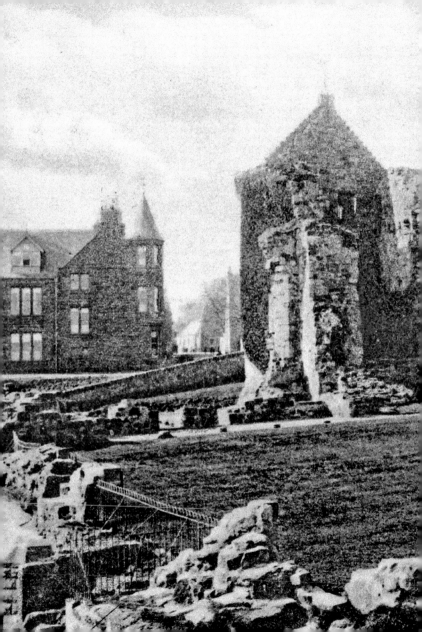

9. THE PALACE OF THE BISHOPS AND ARCHBISHOPS OF ST ANDREWS

St Andrews Castle and its courtyard around 1904. The card here looks south and shows the castle's fore tower, well and entrance. Two wings once flanked the fore tower. On the east was the chapel range with a then fashionable loggia, looking north. Persistent erosion of the cliff on which it stood caused the chapel range to fall into the sea.

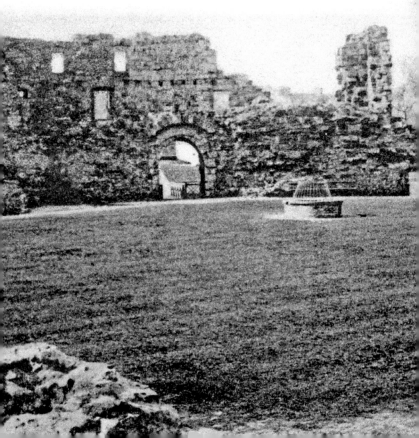

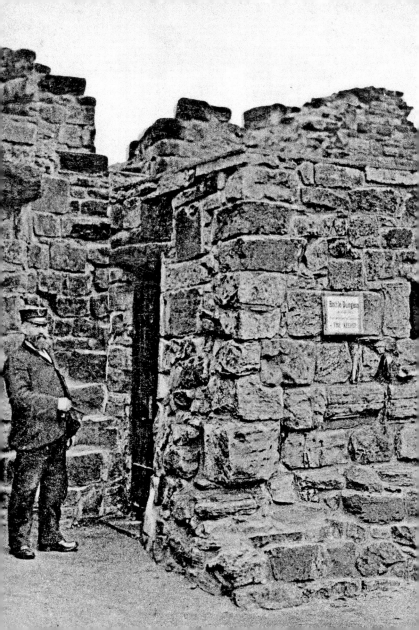

10. ST ANDREWS CASTLE AND ITS DUNGEON

The keeper of St Andrews Castle around 1909. He stands outside its Sea Tower, which dates from 1385–1401. In the tower is the entrance to the castle's infamous Battle Dungeon. Dug out of solid rock, this bottle-shaped pit prison is 24 feet deep and around 15 feet wide at the bottom. Victorian visitors were told prisoners were let down into its depths from transverse beams in the upper room. After his 1546 murder, Cardinal Beaton's body was flung into the dungeon.

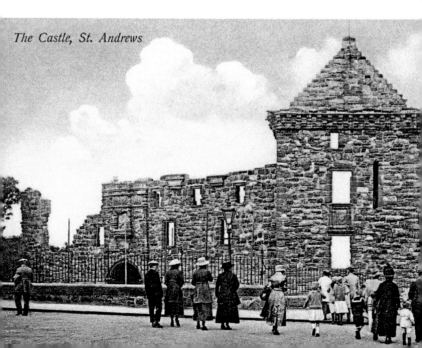

The Castle, St. Andrews

11. SUBTERRANEAN PASSAGE, ST ANDREWS CASTLE

The Lower Chamber, subterranean passage, St Andrews Castle, photographed by Thomas Howie. Today the subterranean passage is recognised as a remarkable example of medieval siege technique dating from the 1546–47 siege of the castle, when the murderers of Cardinal David Beaton were besieged by the forces of the Regent Mary of Guise, mother of Mary Queen of Scots. The subterranean passage consists of a mine dug by the beseigers to gain entry to the castle, and a countermine dug by the beseiged. Both the mine and the countermine were rediscovered in April 1879 when a workman working on a new house opposite the castle fell through the roof of the mine, which was 12–15 feet below. The mine and countermine is now lit by electricity and can be visited.

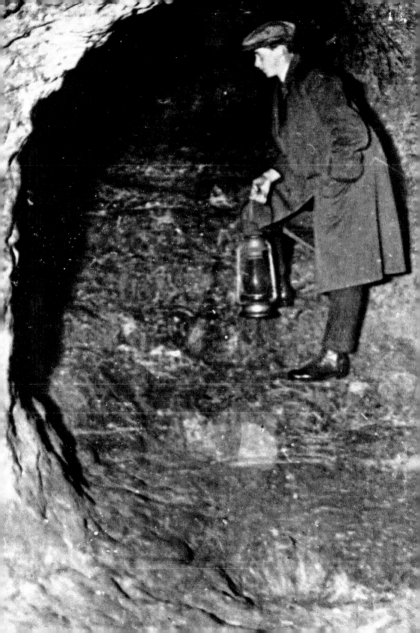

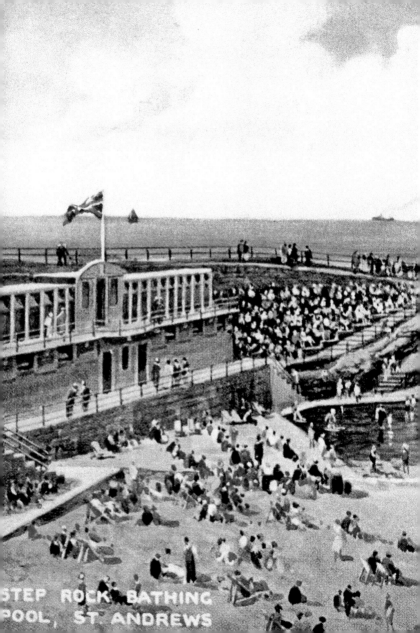

STEP ROCK BATHING
POOL, ST. ANDREWS

12. STEP ROCK BATHING POOL

The Step Rock Bathing Pool was in use as a tidal seawater swimming pool from 1902, until it was replaced by an indoor swimming pool at the East Sands Leisure Centre of 1988. The years 1972–73 saw the pool shortened and repaired. The height of the Step Rock's popularity was in the 1930s, 1940s and 1950s. It was still popular in 1960s, but holiday tastes and expectations were changing. With the pool more than 7 feet deep in the area of the diving board and chute, the pool's gradual entry was a popular feature, as was the children's paddling pool. Part of the Step Rock experience were the trays of tea and coffee available from its kiosk, in company with spades and pails, ice cream and sweets, deckchairs and postcards, while swimming galas, water polo, diving and lifesaving displays were promoted by the Step Rock Swimming Club, which was founded in 1928.

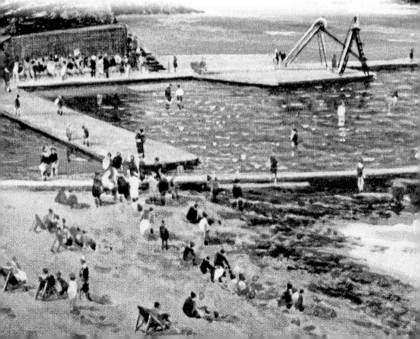

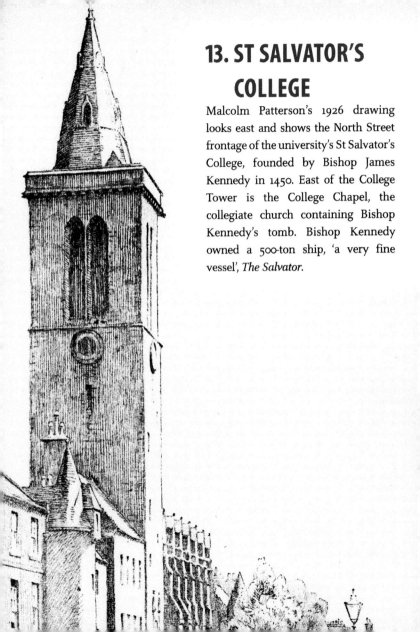

13. ST SALVATOR'S COLLEGE

Malcolm Patterson's 1926 drawing looks east and shows the North Street frontage of the university's St Salvator's College, founded by Bishop James Kennedy in 1450. East of the College Tower is the College Chapel, the collegiate church containing Bishop Kennedy's tomb. Bishop Kennedy owned a 500-ton ship, 'a very fine vessel', *The Salvator*.

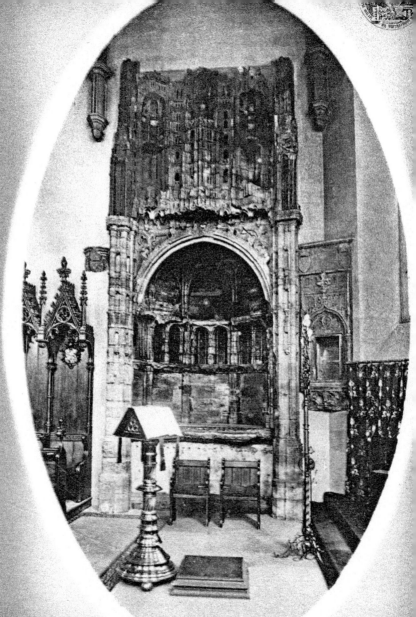

Kennedy's

14. THE CINEMA HOUSE

The art deco Cinema House (1913–79) around 1930, with staff members Alex Gourlay, Charles Findlay, Jimmy Mitchell, and Jack Humphries, the manager of the Cinema House (1928–79). Designed by the Dunfermline architect Robert H. Motion, the Cinema House was both the first St Andrews purpose-built picture house (808 seats and balcony), and one of the earliest Scottish cinemas. The Humphries family have lots of memories of the Cinema House; when the children were older they helped out when there was a sudden staffing crisis. Frances Humphries remembers on such occasions being an usherette, a cashier, and helping in the projection room – 'hand feeding the carbon rods in the machines which produced the light for projection'. The Cinema House became known as the 'old Picture House' or 'the Old', on the opening of the New Picture House in December 1930. Today Muttoes Court, built in 1983–84, stands where the Cinema House once stood.

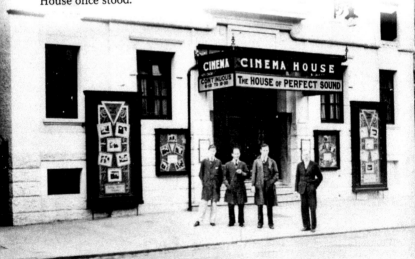

15. NORTH STREET

North Street, looking east to the cathedral before 1928. On the far right is the spire of Martyrs Church. This galleried church was rebuilt (completed in 1928), losing its spire and gallery. The vernacular pantiled building, which stands gable end to the street, was replaced by the New Picture House. The latter had 936 seats, a balcony, a spacious foyer, a café, and opened in December 1930 with the musical *No No Nanette*. Today the New Picture House provides a modern film experience, and is one of Scotland's oldest independent surviving picture houses. Commissioned murals were painted for the New Picture House in the 1930s by the St Andrews exhibition artist Ada Hill Walker (d. 1955), who is remembered as always dressing in soft shades of pink. Martyrs Church merged on 23 July 2010 with Hope Park Church in St Mary's Place. The St Andrews architects Gillespie & Scott designed the New Picture House. Ada's Murals are still in position.

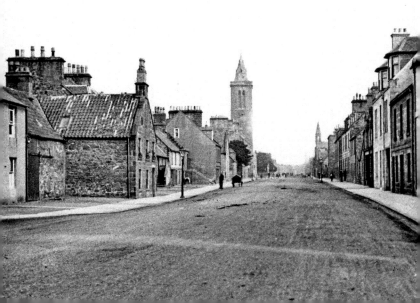

16. GREYFRIARS GARDEN, NORTH STREET

On the far right of 'North Street from Greyfriars Gardens', the graceful spire of John Miller's Martyrs Free Church of 1852 (rebuilt in 1928 and now a university research facility) punctuates the sky. Note 'Gardens' should read Garden. Greyfriars Garden was developed from 1835 to 1844 on the pre-Reformation garden ground of the burgh's Franciscan friary, whose well is still in existence. Greyfriars Garden's earlier name was North Bell Street, in honour of the founder of Madras College. The Second World War saw the creation of the Imperial Hotel with its 1920s ballroom used for military purposes. The family-run Tudor Café was popular for Sunday lunches and teas, when few tearooms opened on a Sunday.

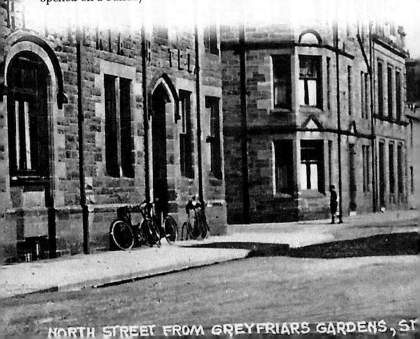

NORTH STREET FROM GREYFRIARS GARDENS, ST

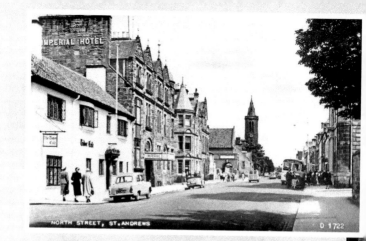

NORTH STREET, ST. ANDREWS

D 1722

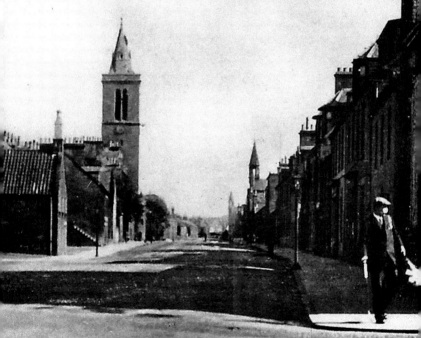

REWS.

Martyrs Monument and Scores, St. Andrews

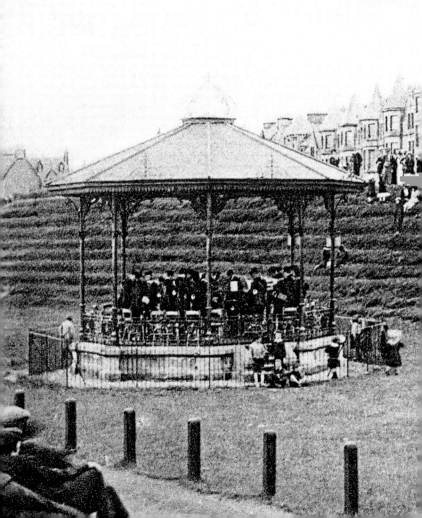

17. MARTYRS' MONUMENT

The Bow Butts bandstand was erected by St Andrews Town Council in 1905. It was made by Walter MacFarlane's Saracen Foundry in Glasgow, famous for its ornamental ironwork. During the summer it is still in use. A still-remembered black cannon was once sited overlooking the Bow Butts. The Scores was developed in the nineteenth century. Only the base of W. Nixons imposing Martyrs' Monument of 1842 is visible in this image. Recently its badly weathered sandstone was refurbished. The monument has fine views over the sea and Links.

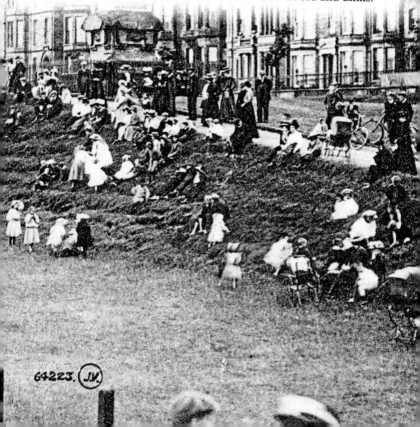

64223. JV.

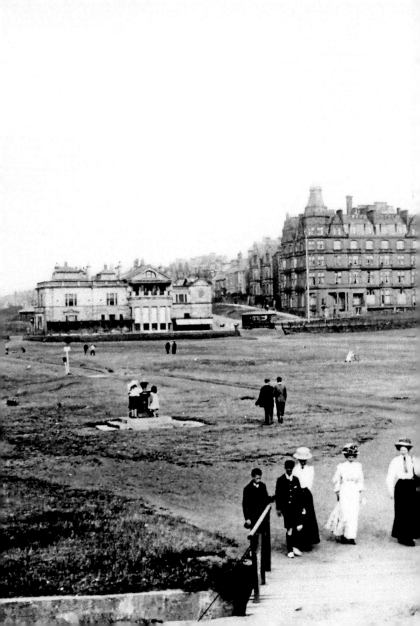

18. THE LINKS

An early view of the Old Course. In the background on the left are the Royal and Ancient Golf Club House and the Grand Hotel, and on the right is Rusack's Marine Hotel as it was then. Opened in 1892 by the Rusack family of hoteliers, the hotel provided every comfort for its guests, including the Palm House. The party in the foreground is crossing the small sandy Swilcan on its way to the sea. After the 1862 demolition of the old town house, stones from it were used to line its banks.

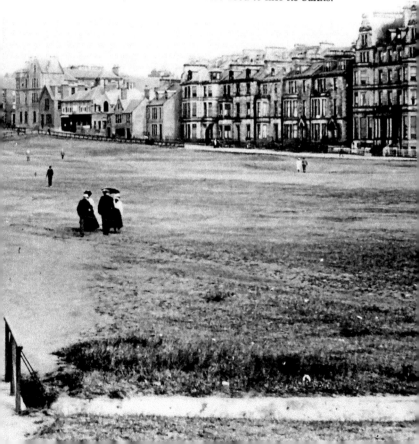

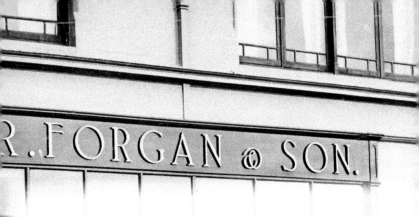

19. R. FORGAN & SON

This photograph was taken on the occasion of a golf match between staff from the famous St Andrews golf club-making and ball-making firm R. Forgan & Son of The Links, and the golf club-making firm Gibson's of Kinghorn. P. L. Forgan, the manager owner of Forgan's, is first on the left of the charabanc's windscreen, and John Forgan, the front shop sales manager, is second from the left in the front row. The date of the photograph is unknown. However, beside the charabanc's horn is Walter Hamilton of Hamilton's Westport Garage. Hamilton's operated charabancs in the 1920s, replacing them in the 1930s with touring coaches around 1935. The photograph includes Willie McIntyre, Forgan's head club maker (second from the right in the front row), and Henry Clark (seated left of the man with the cigarette), the club maker son of Mrs Henry Watters Clark – 'Joan the fishwife'. In March 1963 Forgan's was taken over by A. G. Spalding of America and production was relocated to Belfast. The Forgan's premises were later occupied by the St Andrews Woollen Mill. Today they are owned by the Royal and Ancient Golf Club. Mason's Golf Hotel, which is on the left of the St Andrews Woollen Mill and is now flats, was built on the site of Allan Robertson's 'villa'. Allan's golf balls were made in the kitchen of his home. Allan Robertson Drive is named after him.

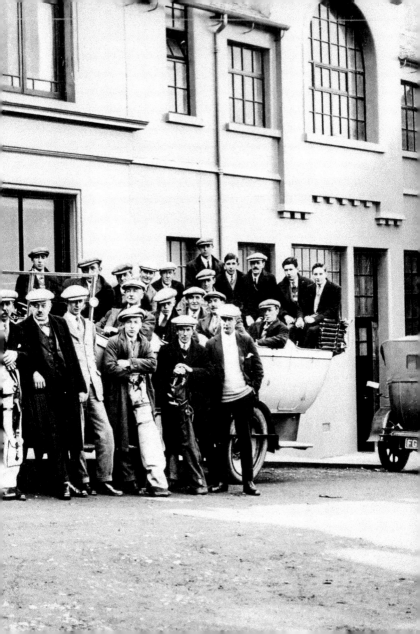

20. THE GRAND HOTEL

The Grand Hotel, built of red Dumfries sandstone, was opened in 1896 with every comfort for its guests and panoramic views of 'the golfing grounds', St Andrews Bay, and the hills beyond. Its site was that of the former Union Parlour, used by members of the Royal and Ancient Golf Club before their clubhouse was built in 1854. Occupied by the RAF during the Second World War, the Grand became a St Andrews University student residence – Hamilton Hall – in 1949. After recent redevelopment it is now the Hamilton Grand. The Links Hotel got its licence in 1863 and Golf Place was developed in 1830–37.

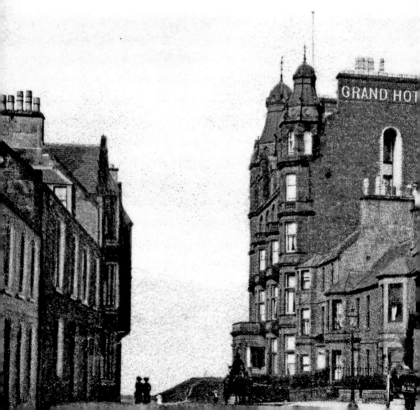

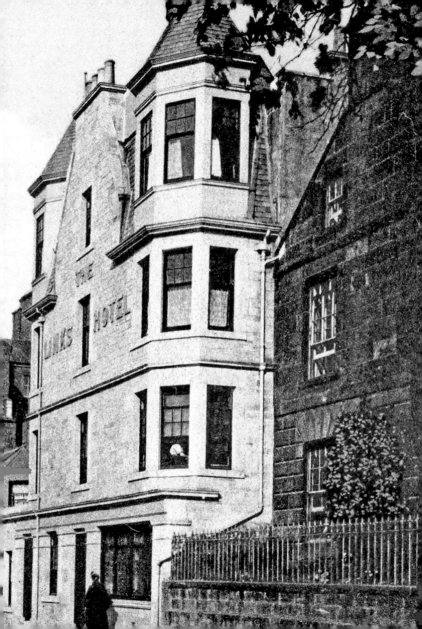

21. THE WEST SANDS

The great expanse of the West Sands stretches from the Bruce Embankment to the estuary of the River Eden. The Swilcan Burn, well known to golfers, enters the sea at the beginning of the West Sands – featured in the famous film *Chariots of Fire*.

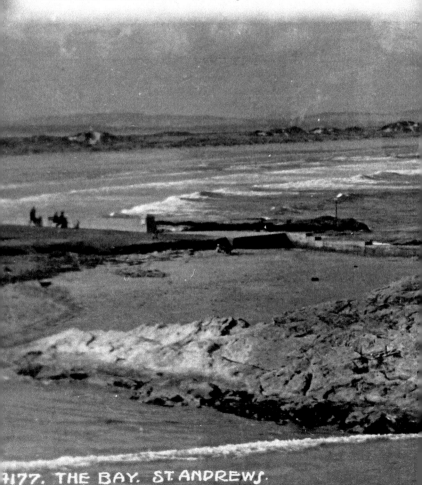

7177. THE BAY. ST ANDREWS.

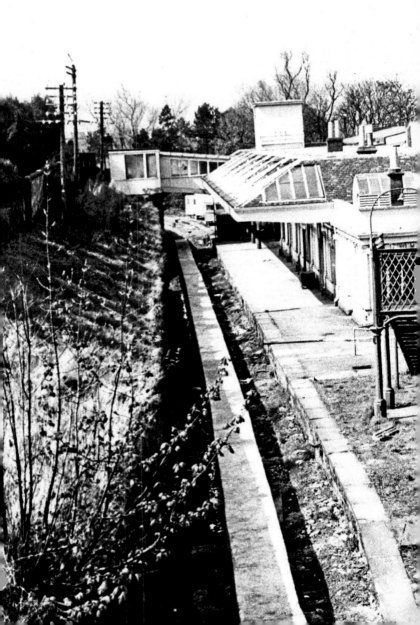

22. ST ANDREWS RAILWAY STATION

St Andrews/Guardbridge/Leuchars Junction railway line was established by St Andrews Railway on 1 July 1852 and closed by British Rail (Scottish Region) on 6 January 1969. The line linked St Andrews to the national railway system. The last train to use this line and St Andrews station was the Leuchars 11.07 p.m. train to St Andrews on 4 January 1969.

A path between the wall and the station railings with the ironwork stair gave pedestrian access to the station from Double Dykes Road. Before their demolition in October 1972 the empty station buildings were used by the then Ichthus Youth Club. The inset shows the north end of the station during its demolition, and the main station entrance with its covered in walkway in Station Road. Built as part of the Anstruther/St Andrews Railway (1880–87), the station replaced the town's original Links station near the 17th hole of the Old Course. The Links station then became the town's goods station; closed in June 1966, the station is now the site of the Old Course Hotel. Part of the hotel complex is the Jigger Inn, once the St Andrews stationmaster's house.

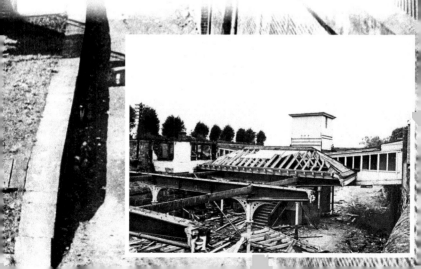

23. HOWIE'S TOYSHOP

Thomas Howie's toyshop at No. 4 Bell Street in 1921. Standing at the door (left) with her husband, Thomas, is Mrs Ann Howie. Miss Lizzie Black (on the far right) was employed by Thomas Howie and later took over this well-remembered business. After Miss Black's retirement, the business was bought by the Scouller family, who were its owners from 1958–85. Many treasured toys were bought from Howie's, as were lots of schoolbags, hockey sticks, and tennis racquets. In our family we have a Howie's 1960s trainset, and a pre-decimal toy cash register. Thomas Howie was a keen amateur photographer. A café now stands on the former site of Howie's toy shop.

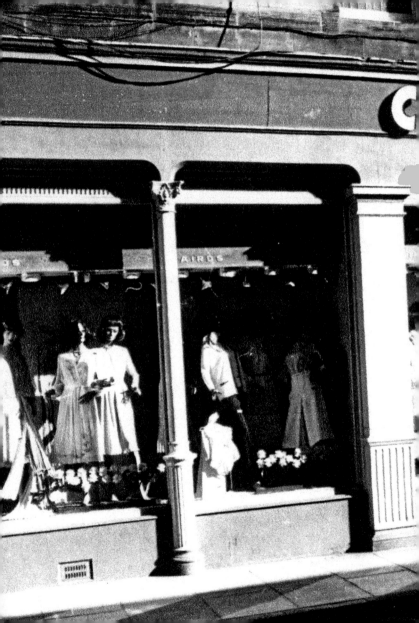

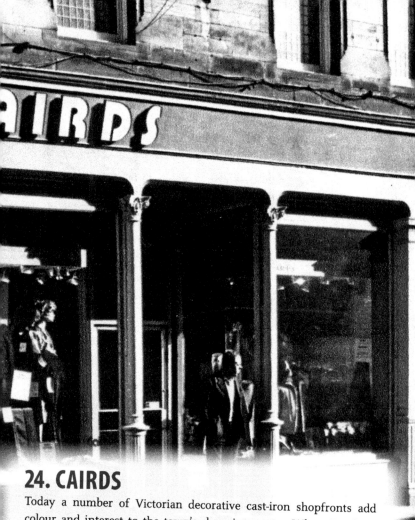

24. CAIRDS

Today a number of Victorian decorative cast-iron shopfronts add colour and interest to the town's shopping centre. When Cairds of Dundee opened in Bell Street its cast-iron frontage was already in position, where it remains today as a frontage for a restaurant. Cairds closed in 1984. 'Watch's' frontage is also decorative cast iron.

25. ST ANDREWS LAMMAS MARKET

An Edwardian 'St Andrews Fair – Sliders' shows Market Street at its intersection with Church Street. Part of the premises of W. C. Henderson (in business 1855–1985) is visible behind the ice cream seller (a 'slider' is two wafers sandwiched together with ice cream). Henderson's of No. 19 Church Street and No. 80 Market Street were printers, publishers, booksellers, stationers, and postcard publishers. St Andrews Lammas Market is still held in the main streets of St Andrews in early August. It is the only survivor of the burgh's five markets and is one of the oldest European medieval markets, and the oldest in Scotland.

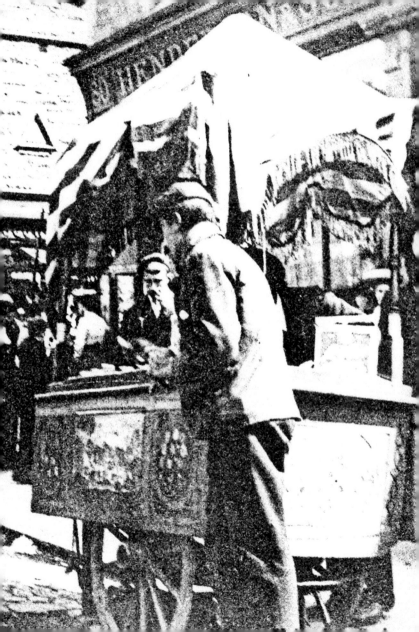

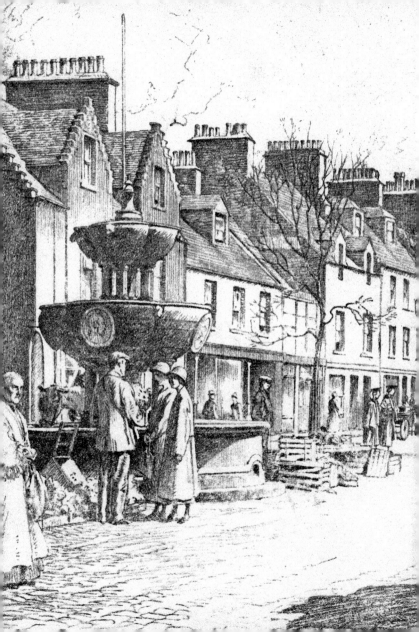

26. THE FOUNTAIN

Two charming postcards featuring the memorial fountain for the novelist George Whyte-Melville of the Whyte-Melville family of Mount Melville, who was killed in 1878 on the hunting field. The fountain, completed in 1880, was funded by public subscription. A fountain was chosen by his mother, Lady Catherine, to provide water for horses and dogs. After a long period 'dry', July 2015 saw water flowing again from the fountain. The fate after 1768 of the burgh's Market Cross is unknown. It stood near the fountain. The Fairfield Stores (right) closed in 1992; the owners 'lived above the shop' in traditional fashion in the 1950s.

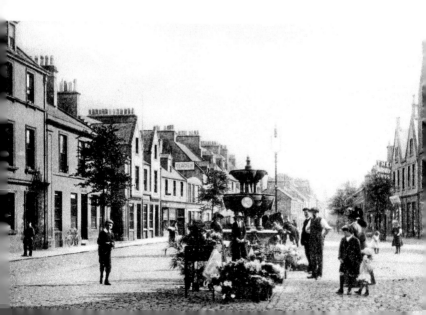

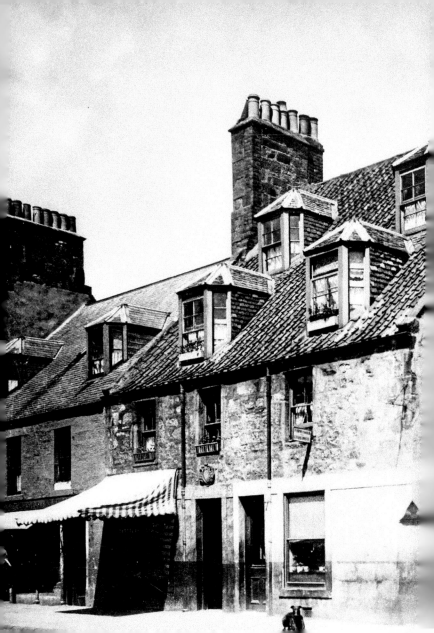

27. THE 'DOUBLE DECKER', MARKET STREET

The 'Double Decker' around 1890. This old crowded tenement of housing and shops stood on the corner of Market Street and the west side of Union Street. Its distinctive double row of attic windows gave the building its nickname. There was no other surviving roofscapes of its kind in St Andrews. It was possibly inspired by the town's centuries of trading with the Low Countries. There is a tradition that John Knox (1507–72), the leader of the Scottish Reformation, stayed in the 'Double Decker' – if true it would have been in an earlier building on the same site. After the building caught fire in 1926 it was condemned, and was demolished along with the substandard housing on the west side of Union Street in 1934. The university's Buchanan Building, completed in 1964, occupies the 'Double Decker's' site, and that of Black's Close or Union Lane, also the west side of Union Street. The last owner of the 'Double Decker' was Miss Jetty Bruce, having belonged to her father George Bruce.

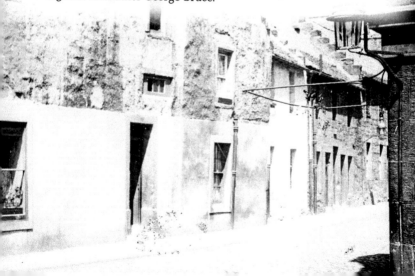

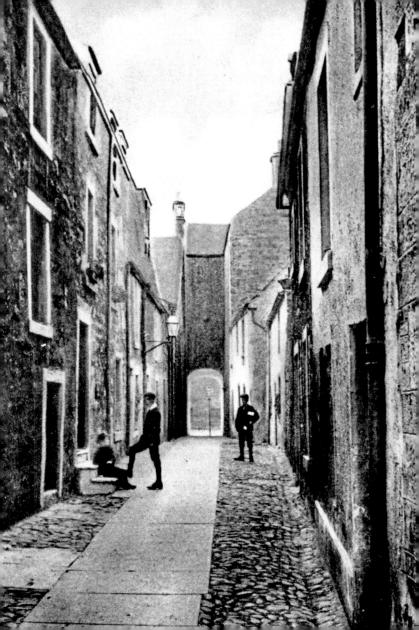

28. BAKER LANE

Baker Lane, looking towards South Street from a George Fleming postcard Called Baxter (baker) Wynd in the fifteenth century, Baker Lane was almost completely redeveloped by the town council in the 1950s. The redevelopment culminated in the 1960s in the demolition of the old model lodging house for men, which stood on the east corner of Baker Lane and the narrow end of Market Street. Council flats replaced the buildings demolished on the east side of the lane, and a pretty, urban green space replaced the houses demolished on the west side of the lane, which were built with their backs to the wall of the medieval garden of St John's House. The gable end of St John's House in South Street features prominently in both images.

Today the remains of the old weathered carving on St John's gable often referred to as 'Pontius Pilate' are hardly decipherable.

29. DEANSCOURT

A view of Deanscourt near the cathedral, The Pends, and Priorsgate, a later extension of Queen Mary's House. Before the Reformation, Deanscourt (now a university property) was the archdeacon's manse. Reconstructed around 1570 by Sir George Douglas, it has a walled garden, well, and a gated entrance with Sir George's arms (d. 1606). Handsome Sir George – 'Pretty Geordie' – and young Willie Douglas helped Mary Queen of Scots escape from Loch Leven Castle in 1568.

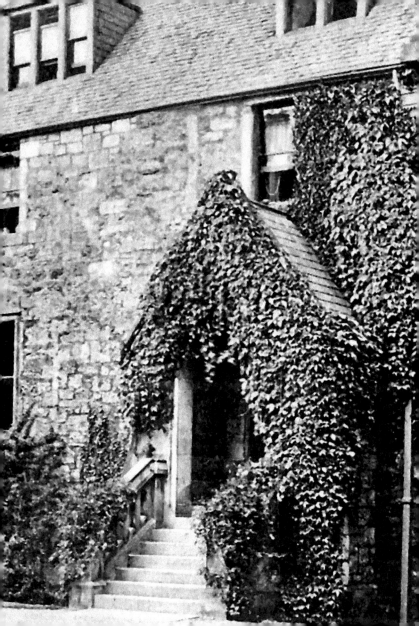

30. QUEEN MARY'S HOUSE

A view of the south-facing decorative garden frontage of 'Queen Mary's House'. It stands at the east end of South Street near the cathedral and The Pends. The St Andrews merchant Hew Scrymgeour began building it in 1523. It is so named because Mary Queen of Scots, holidaying in the burgh in 1564, occupied a suite of rooms in it. She is traditionally associated with the corner oriel, seen here wreathed in greenery. The house would have been well known to Sir George Douglas. It was renovated in 1927 as a library for Sir Leonard's School.

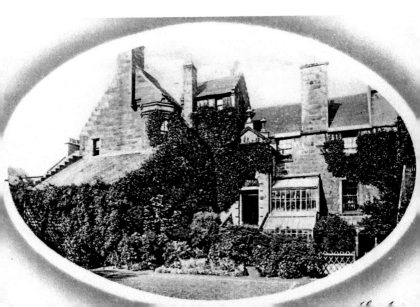

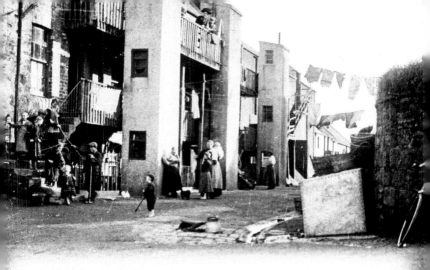

31. THE 'ROYAL GEORGE'

The back of the 'Royal George' fisher tenement at the harbour in around 1909. Only a narrow road separated the building from the gasworks. Originally a Shorehead warehouse, the building was heightened and attics were added as were outside toilets, when around 1869 the building was converted by the property developer George Bruce of Market Street into room and kitchen dwellings for fisher families. Bruce had a lifelong interest in the fisher folk, the fishing industry, and the St Andrews lifeboat. The 1930s saw the 'Royal George' condemned as a slum. It was empty of tenants by 1935 – a gaunt shell of a building. After the demolition of the gasworks in 1964 the 'Royal George' was developed as private housing, in company with neighbouring Shorehead buildings. The overcrowded conditions of the 'Royal George' was responsible for its local nickname. The RNS *The Royal George* sank 29 August 1782 when being repaired at Spithead. She was crowded with crew and visiting families, many of whom were drowned. The 'Royal George' helped relieve the overcrowding in the Ladyhead, when the number of fisher families in the town was increasing.

32. ST ANDREWS GASWORKS

The St Andrews Gasworks staff outside the building early in the 1900s. The St Andrews Gas Co. was formed in 1834, and gas was made at the gasworks from 1835 until February 1962. The gasworks were greatly increased in size in 1918 to cope with the demand for gas in an expanding St Andrews. The year 1949 saw the company become part of Scottish Gas and the gasworks were demolished in 1964. Today the former gasworks site is open space bordered by a restored stretch of the priory wall. Today's Kirkheugh Cottage was once the home of the gasworks foreman. At one time on special occasions the Gas Co.'s employees wore slouch hats, navy trousers, and matching jerseys with the logo of St Andrews Gas Co.

A last link with the original St Andrews Gas Co. was severed when the town's two gasometers, erected 1903 and 1932, were dismantled in 2003. They were no longer required because of modern advances in the storage and supply of gas to the town.

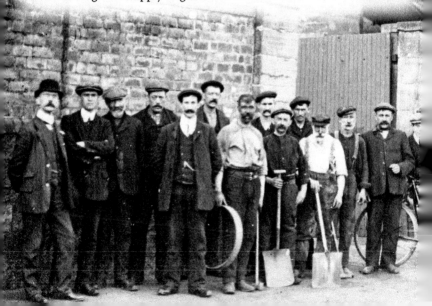

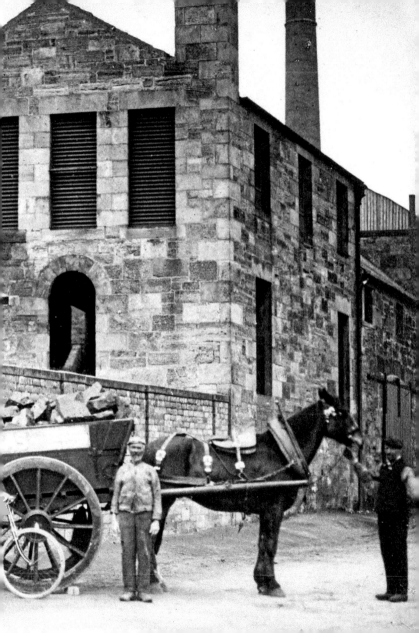

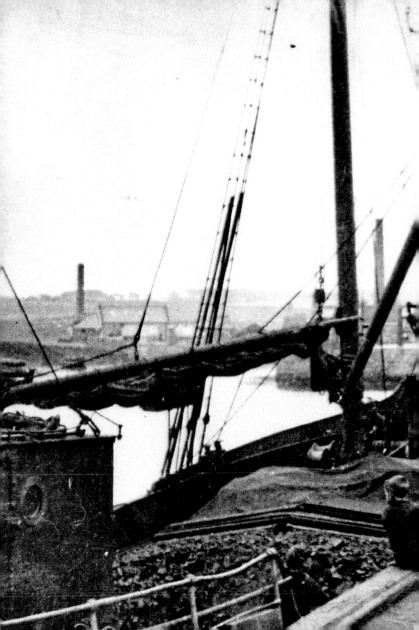

33. THE HARBOUR

Coal being unloaded in the inner harbour for the gasworks around 1921. Shipments of coal for gas varied from 7 tons to the 120 tons brought in by the steam coaster SS *Locksley*. Built at Wallsend in 1884 she was thought to be the last cargo ship to enter St Andrews Harbour with coal for the gasworks. She was wrecked in the 1930s at Lindisfarne. Potatoes, grain, wood, fertiliser and salt were shipped in and out of the harbour at this time, and in earlier years. On the right is part of enclosing precinct wall of St Andrews Cathedral and priory, and in the distance is the chimney of Woodburn Laundry. Over the years a considerable number of women from local fishing families worked in the laundry.

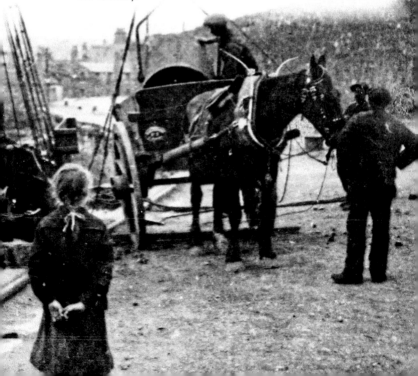

34. THE BYRE THEATRE

The first Byre Theatre (1933–69) in Abbey Street. Its interior is seen here on the occasion of the 1951 performance of an adaption of Sir Walter Scott's *The Heart of Midlothian*. The theatre had seventy-four seats and the stage measured 14 feet by 12 feet. The first Byre Theatre was founded by the St Andrews journalist and playwright Alex Paterson (1907–89), in company with a group of local amateur drama enthusiasts. Alex Paterson MBE, MA, became a prominent figure in Scottish amateur drama. The theatre on the west side of Abbey Street was a DIY conversion of the byre (cowshed) of the untenanted Abbey Street Dairy farm, a burgh farm. The byre was rented from the town council for an annual £10. George Cowie, the photographer, was skilled in joinery and involved in the conversion, and later his son Andrew was closely involved with the lighting and stage management of the Byre. The first Byre Theatre was demolished in the widening of Abbey Street and was replaced by the second Byre Theatre.

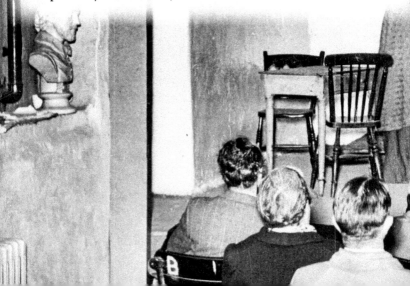

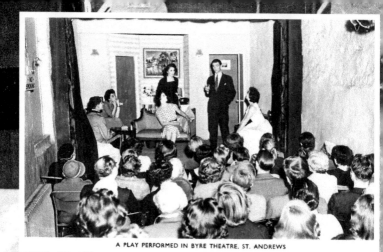

A PLAY PERFORMED IN BYRE THEATRE, ST. ANDREWS

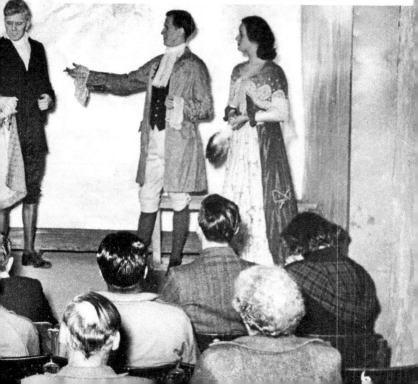

35. ABBEY STREET

The beginning of the building of the second Byre Theatre on the west side of Abbey Street, not long before the December 1969 demolition of the Crown Hotel (partly seen on the left), sited on the east side of the street. June 1969 saw the last day that the Crown Hotel traded. The second Byre Theatre (1970–96) was modelled on the London Mermaid Theatre and had 145 seats. Built on a site in Abbey Street, it was 30 yards north of where the original Byre Theatre had stood.

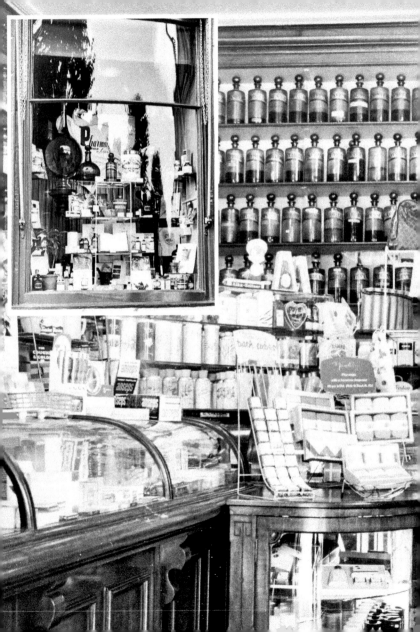

36. SOUTH STREET

0. 73 South Street is remembered as 'Keith the chemist's'. After A. W. Keith's death in 1966, the business was taken over by T. W. McKechnie (chemist and optician) until his retirement. This image is a look at the window display and the interior of the shop when it was a chemist's – note the wonderful display of antique glass jars, which were once in daily use when pharmacists rolled their own pills and made up prescriptions. Today No. 73 South Street is occupied by Keracher the fishmonger, a long-established family business formerly of No. 108 Market Street. No. 73 South Street's neighbour (on the right) is the university's St John's House. One of the oldest town houses in St Andrews, it was once owned by the medieval military order the Knights Hospitaller, and before that possibly by the Knights Templar.

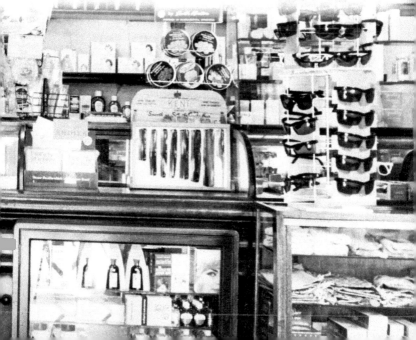

37. SOUTH STREET

The south facing façade of the centuries old South Court at Nos 40–42 South Street. This was taken in 1937 before its 1968–72 restoration, when it was in company with its neighbour on the east, Nos 36–38 South Street, the 'Great Eastern', which in the early sixteenth century belonged to St Andrews Priory. The renovation was carried out by the owner of the buildings, St Andrews Town Council, and when completed provided thirteen small flats (originally for older people) from this grouping of historic buildings. During South Court's renovation evidence of former painted walls and ceilings were found.

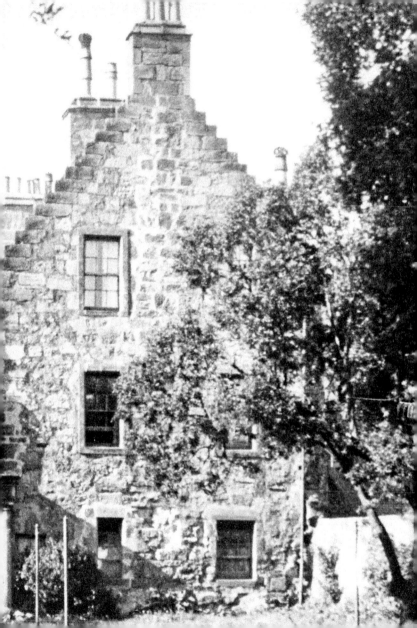

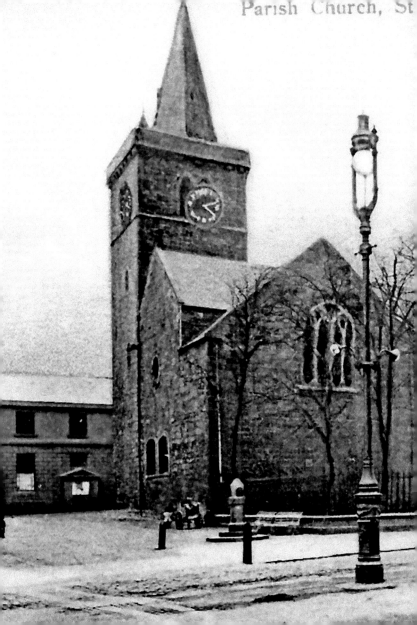

38. HOLY TRINITY CHURCH

Views of the church of the Holy Trinity – 'The Town Kirk' in South
Street – founded by Henry Wardlaw, Bishop of St Andrews (1403–40).
Trinity Church is clearly marked on a 1642 Plan of St Andrews.
Wardlaw's parish church replaced an earlier one near the cathedral
(1798–1800), which saw the town church undergo major alterations
(excluding its tower and steeple) when it became a galleried church.
It was restored as near as possible to its medieval form (1907–09).

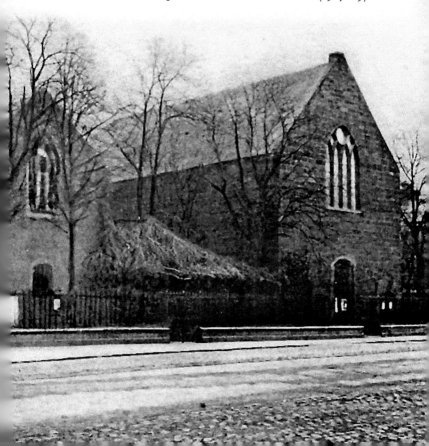

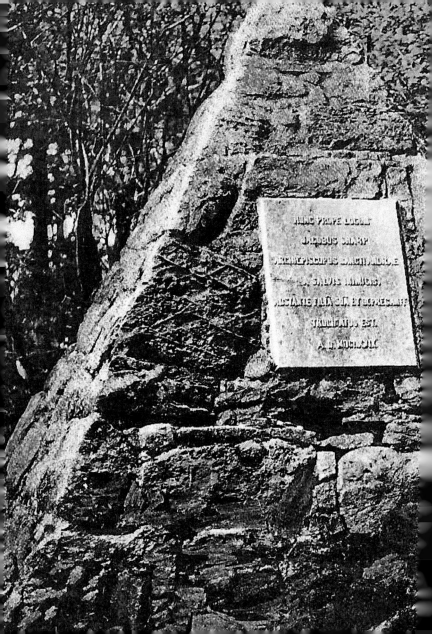

HUNC PROPE LOCUM
JACOBUS SHARP
ARCHIEPISCOPUS SANCTI ANDREÆ
D. SALVIS HOMINIBUS
ADSTANTE FILIA SUA ET DEPRECANTE
TRUCIDATUS EST
A. D. MDCLXXIX

39. A MURDER AND A MARBLE TOMB

On 3 May 1679, on Magus Moornear St Andrews, Dr James Sharp, Archbishop of St Andrews, primate of all Scotland, royal chaplain to Charles II, was dragged from his coach by a band of Covenanters and murdered. His St Andrews funeral took place on 17 May 1679, and included his coach. His marble tomb is in Holy Trinity Church. Kinkell Braes stones were used for the cairn, which marked the spot of his murder.

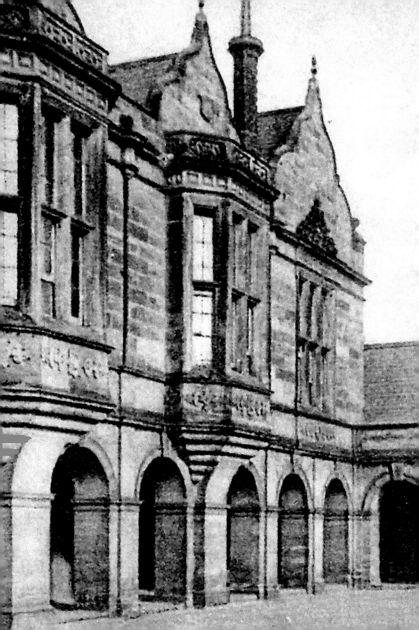

40. MADRAS COLLEGE

Madras College was founded in 1832 by the St Andrews-born educational reformer Revd Dr Andrew Bell (1753–1832), who promoted his own Madras, or monitorial, teaching system. Built of local sandstone, the co-educational school incorporated the town's grammar school (boys only) and the English School, and was built in the grounds and gardens that once belonged to the St Andrews house of the Blackfriars or Dominicans. The arches of the school's quadrangle, 'The Quad', were bricked up to shelter pupils and staff during the air raids of the Second World War.

41. ST MARY'S COLLEGE, THE UNIVERSITY OF ST ANDREWS

A view of St Mary's College in South Street; the photograph dates from 1909. Built on the site of the old 'A Pedagogy' of 1430, the college was founded in 1537 and was completed in 1554 by Archbishop John Hamilton, whose arms are over the entry to the bell tower. Queen Mary's thorn is believed to have been planted by Mary Queen of Scots. Note the view of South Street seen through the college's entrance archway.

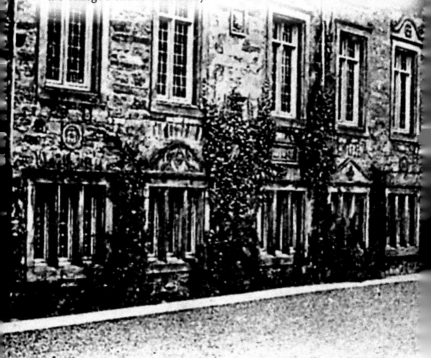

St. Mary's College, St. Andrews

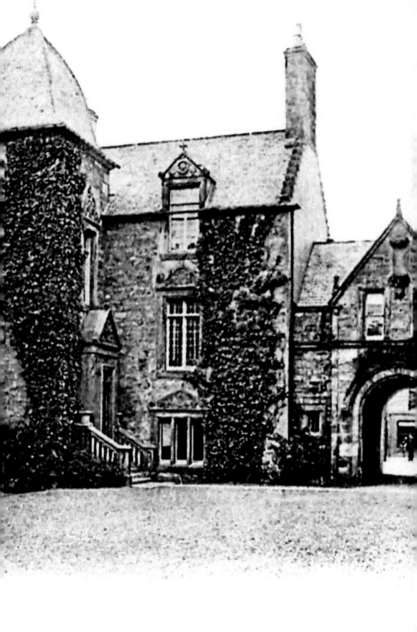

42. WEST PORT

This 1929 postcard of the West Port was photographed and published by Thomas Howie, who owned a toyshop at No. 4 Bell Street. Note the schoolgirl's old-style gym tunic. The West Port, that is the Southgait Port once the principal entrance to St Andrews, is the only surviving St Andrews town port. It appears on a 1642 plan of St Andrews as the Southgate Port and was built in the style of Edinburgh's Netherbow Port. The period 1843–45 saw the renovation of the West Port when side arches were first inserted, and 'elegant and powerful' buttresses replaced its old guard houses.

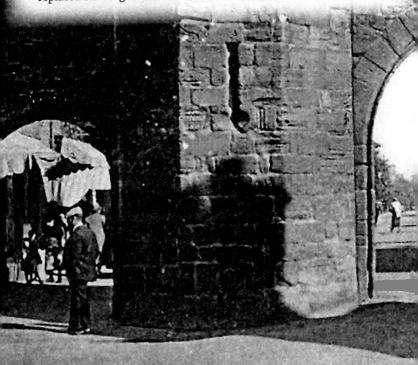

THE WEST PORT ST. ANDREWS.

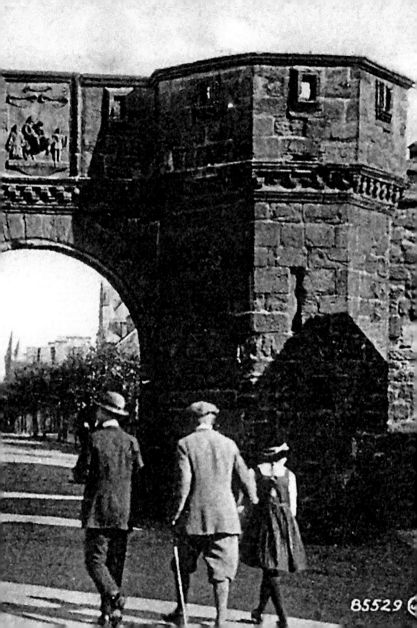

85529

43. KINBURN HOUSE AND ITS PARK

Kinburn House and its grounds were acquired by St Andrews Town Council in 1920 to be used as a public park. Today Kinburn House is St Andrews Museum, which has exhibition space and a café, complemented by the park's seasonal bowling, putting and tennis. Kinburn House and its grounds were built and laid out in 1854–56 on former pasture land, with panoramic views north over a then undeveloped North Hough. The mansion was built by St Andrews man Dr David Buddo (1800–60) on his retirement from the Indian Medical Service.

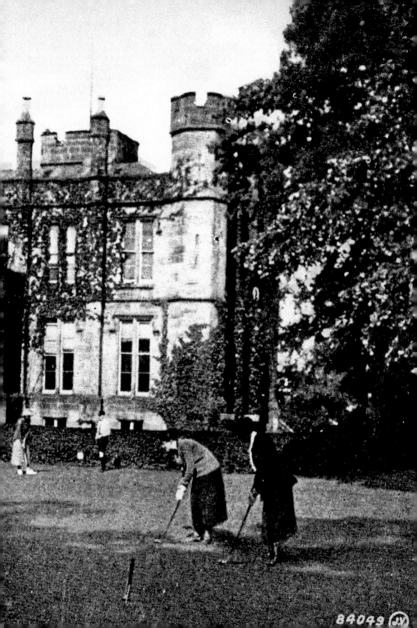

84049 (JV)

44. THE LADE BRAES

A view of the Lade Braes Walk, which stretches from the south-west end of Queen's Terrace to Law Mill. This old image was photographed by George Cowie around 1950. On the left is the lower path that runs beside the Kinness Burn. The Lade Braes is a walk loved by many, particularly the part from Cockshaugh Park to Law Mill, which is punctuated by the former New Mill, or Plash/Splash Mill. This part of the Lade Braes, then surrounded by open country, was developed in the nineteenth century along the braes (slopes) of the common lade (lead), which has been drawing water from the Kinness Burn since the thirteenth century. Two St Andrews men, who served on the town council, developed and enhanced the Lade Braes as a walk: John McIntosh, who was the master mason for the new town hall, and the architect John Milne. McIntosh covered in the lade and planted trees, while Milne planted both trees and shrubs. An inscribed stone and a memorial fountain on the Lade Brae Walk commemorates their work. The deepest pool sited beside the lower path was always known to my family as 'Eppies' Hole'.

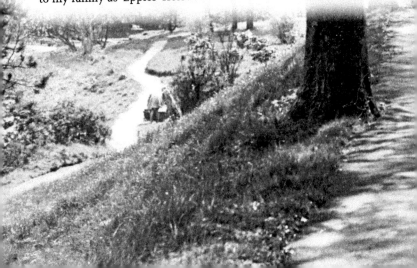

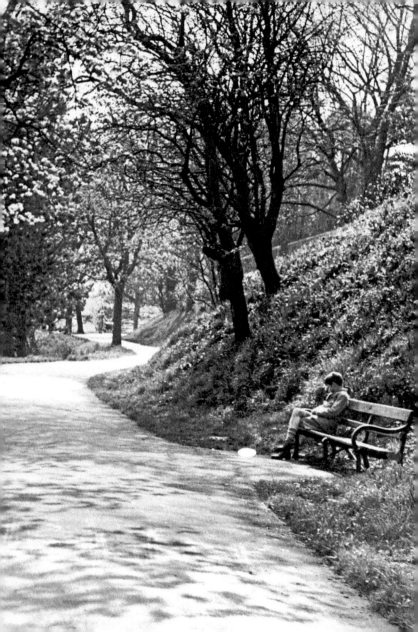

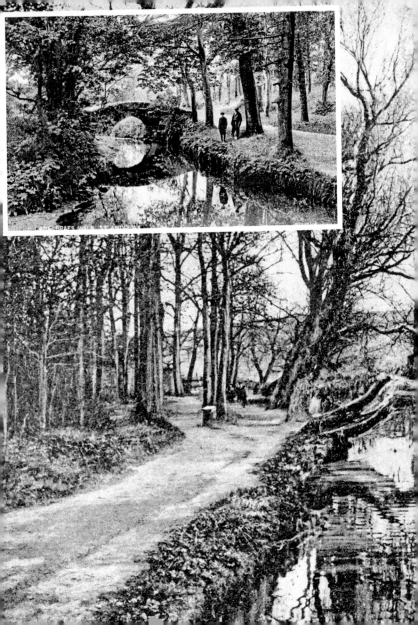

45. THE LADE BRAES

The image here shows Law Mill or Nether Mill of Balone. Its exact age is unknown, but there is a reference to it in 1570. In its working days, its waterwheel, with its two sets of grinding stones, was powered by water from the Lumbo and Kinness burns. Thomas Nicol (or Nicolls), who ground corn and barley, occupied the mill from 1848 to 1913. By 1905 there was little work for small local millers and the waterwheel fell into disuse. The inset shows the 1792 Law Mill Bridge that spans the Kinness Burn and leads to Law Mill, sometimes referred to as Law Green Mill.

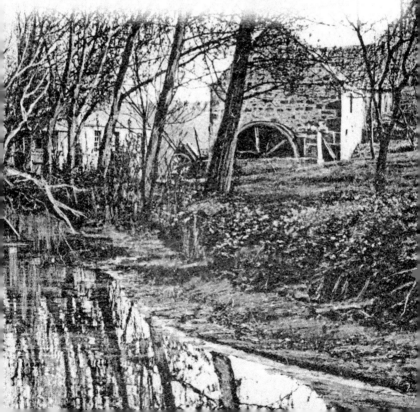

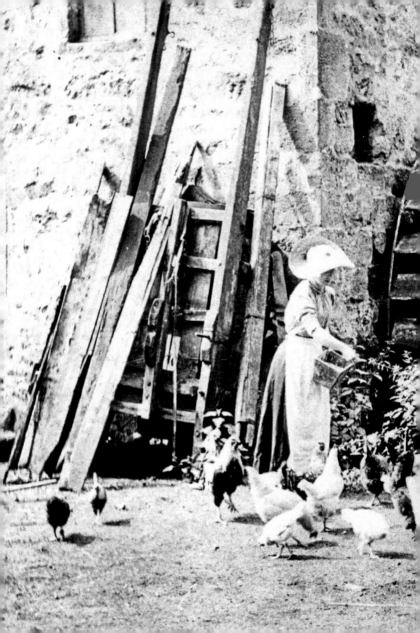

46. THE LAW MILL

An early image of Mrs Rachel Nicoll (Rachel Miles), the miller's wife, wearing a countrywoman's sunhat, feeding the hens at Law Mill. The latter shows the breast-shot waterwheel, which once powered the Law Mill with its two sets of grinding stones. The last working millers at Law Mill from around 1850s were the corn and barley millers, the Nicol/Nicoll family. By 1905 the waterwheel was no longer in use (times were then hard for small millers) and by 1913 the Nicoll's were bankrupt. The Law Mill first belonged to St Andrews Priory, leading to the lade, on occasion, to be referred to as the 'Prior's stream'. From around the 1660s the mill belonged to the burgh of St Andrews – today Law Mill is private property.

47. CRAIGTOUN COUNTRY PARK

Views of the 'Dutch Village' at Craigtoun Country Park near St Andrews. The Dutch Village was one of the features of the landscaped gardens and grounds of Mount Melville House, part of the Mount Melville estate, owned by James Younger (1856–1946). The year 1947 saw the mansion and its grounds acquired by Fife County Council. The mansion became a maternity hospital, then a care home (closed in 1992), its gardens and grounds becoming Craigtoun Country Park. The historic Mount Melville estate was originally called Craigtoun. The Georgian mansion, which was demolished by James Younger and replaced by his Mount Melville House, was the home of the novelist Major George Whyte Melville (1821–78), who is commemorated by the fountain of 1880 in Market Street. Craigtoun Country Park is rich in birdlife, wildlife and trees. Other amenities include bowling, boating and putting. The architect who designed Mount Melville House and landscaped its gardens was Paul Waterhouse, who also designed the university's Younger Graduation Hall.

CRAIGTOUN PARK, ST. ANDREWS.

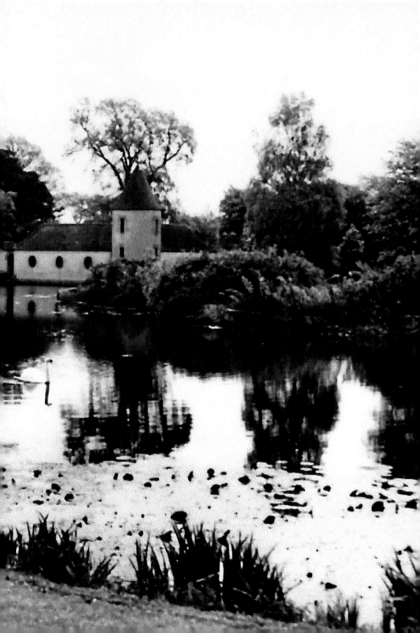

ACKNOWLEDGEMENTS

I wish to thank St Andrews Preservation Trust for help in sourcing period photographs from their photographic collection for this book. Details of the trust's work can be found on the website www.standrewspreservationtrust.co.uk

Also, thanks go to Dr John Frew for information about cast-iron shop frontages in St Andrews – see his *St Andrews Shop Fronts 1820–1940: An Illustrated Survey* (St Andrews Preservation Trust).

The text of *St Andrews History Tour* is based on my previous research and writing on St Andrews.